Inspiration & Context: The Drawings of Albert Paley

Exhibition organized by the
Memorial Art Gallery of the University of Rochester

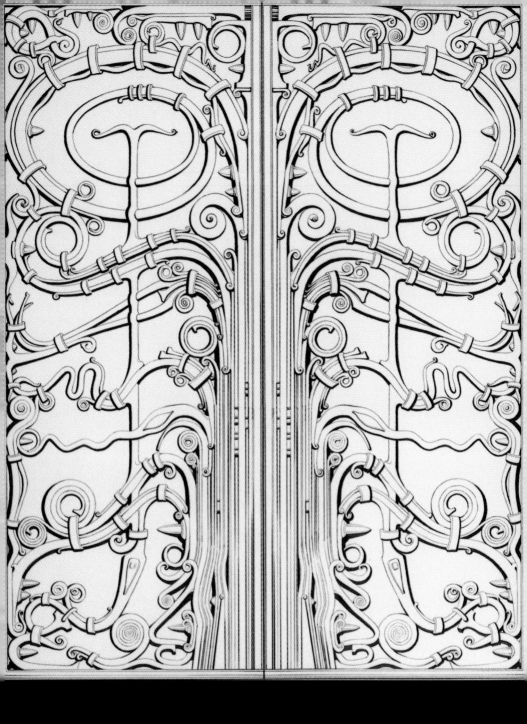

frontispiece:
Reinterpretation of the Portal Gates for the Renwick Gallery, 1992.
Graphite on paper, 48 x 35¹/₄ in. (122 x 90 cm). Collection of the artist (GA 92.1).
Commissioned by the Renwick Gallery, National Museum of American Art,
Smithsonian Institution, Washington, D.C., in observation of its twentieth anniversary.

Acknowledgments

The Memorial Art Gallery takes great pride in organizing the first major exhibition of the drawings of Albert Paley. An internationally acclaimed artist who has changed contemporary metalworking from a "utilitarian craft into a dynamic art form," Paley has also been an influential and active member of the Memorial Art Gallery. He was the subject of a major Gallery exhibition in 1985 and was commissioned to design an architectural screen for the new Vanden Brul Pavilion. In addition, he has served as a member of the Board of Managers, and in 1989, he received an honorary doctorate from the University of Rochester. As artist and friend, it is therefore appropriate that the Memorial Art Gallery celebrates Paley's achievements in "Inspiration & Context: The Drawings of Albert Paley."

I want to extend the Gallery's deep appreciation to the many individuals that helped make this exhibition possible, especially the artist himself and his remarkable assistants, Tom Bushnell and Stacey VanDenburgh. The exhibition catalogue is due to the ardent support and efforts of Skip and Susan Hansford and the generosity of Elaine P. Wilson and the Canandaigua Wine Co., Inc. Mildred Schmertz's insightful essay makes a significant contribution to our understanding of the work of Albert Paley. Pamela Barr (editor), Bruce Miller (photographer), and Mark Lichtenstein (designer) are also to be commended for their roles in creating this important document. I also want to express my gratitude to the entire staff of the Memorial Art Gallery, which, directly or indirectly, is involved in every major exhibition. We are especially indebted to Laurene Buckley (Assistant Director for Curatorial Affairs), John King (Exhibition Designer), Susan Dodge Peters (Assistant Director for Education), and Deborah Rothman (Public Relations Manager). Finally, I want to salute Richard F. Brush, whose generosity and enthusiasm continue to support and enhance the Gallery's mission.

Grant Holcomb
Director
Memorial Art Gallery

From Lines

in Pencil

to Forms

in Space

Albert Paley's drawings are the link between his creative imagination
and the architectural sculpture, ornament, and objects of decorative art
he has been producing since 1973, the year he established Paley Studios
Ltd., in Rochester, New York, and began to work in iron. Like an archi-
tect, Paley begins a project by making dozens of quick, fluid, conceptual
sketches leading to clarity of thought and form, follows them with draw-
ings through which he studies texture and detail, and eventually
progresses to a finished rendering. Unlike an architect, however, who
must follow his renderings with working drawings to guide the building

contractors, Paley creates a final presentation drawing, which, after client
approval, becomes the guide to actual fabrication in his studio, where
further improvisation may occur as he works with the metal. Whatever
the project, be it architectural sculpture, ornament, gate, screen, table,
lamp, or candlestick, Paley begins developing the form by drawing rather
than by direct manipulation of the iron. "The drawings enable me to

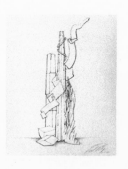

experience and completely understand the form before going into metal
and to explain the form to somebody else. After that communication is
understood, I go into the studio." [1] Paley makes no further graphic studies
and considers fabrication drawings an unnecessary procedure. He works

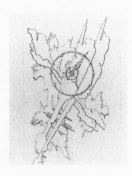

with his assistants in his studio about three days a week, cutting, spin-
ning, forging, and bending heated iron. Forging is tough work, requiring

[1] Quotes from Albert Paley, conversations with the author, June 24 and October 30, 1993.

4

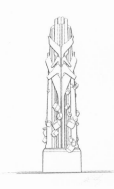

great physical strength. "I am on the floor all the time, working the metal as I adjust for distortion because of foreshortening, checking for structural rigidity, and translating two-dimensional patterns into three-dimensional forms." The rest of his working life is spent alone in his drawing room, which is soundproofed against the din of the hydraulic hammers emanating from the shop. Here, he conceives and develops his remarkable essays in iron by making drawings and cardboard models.

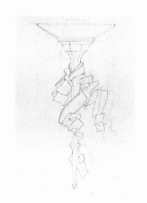

In the mid-1960s, Paley attended the Tyler School of Art at Temple University in Philadelphia. Upon receiving a B.F.A. and an M.F.A. from Temple, he began as a jeweler working in malleable metals —gold, silver, and copper. His necklaces, pendants, and brooches bear little resemblance to what other jewelers were doing at the time. They are larger in scale and defy the prevailing conventions of form and craft.

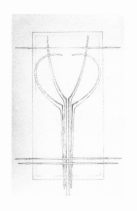

His jewelry reveals instead the influences of prehistoric bone ornaments, African amulets, and, perhaps most important for the work in iron that was to follow, the various aesthetic streams that flowed together to form Art Nouveau. These streams, including the Baroque and Rococo periods, the English Arts and Crafts Movement, and the Gothic Revival, as well as Japanese painting and graphics, served as models for the jeweler and continue, indirectly and even subliminally, to inspire the sculptor in iron.

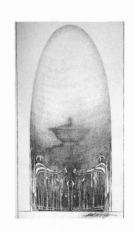

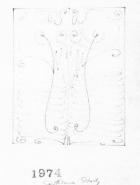

1974

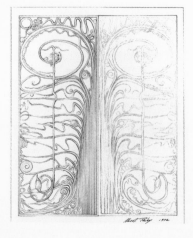

Paley was to transform himself from jeweler to sculptor upon winning a 1973 competition for the design of the portal gates of the Renwick Gallery of the Smithsonian Institution in Washington, D.C., a high-Victorian building designed by James Renwick in 1859. "I moved from ornamenting human form to ornamenting architectural space," Paley explains, acknowledging that he probably will never return to jewelry. "Before beginning with architectural work, I was always very improvisational in dealing with form. I never made preliminary drawings for my jewelry. Only when I was doing the Renwick gates did I turn to drawing to develop the concepts and ideas." The gates, made of steel, brass, and bronze and completed in 1974, were intended to be as richly detailed as their opulent setting, ornamented with mosaics and large variously colored stones. The earliest drawings for the project (cat. no. 1) are linear, light, quick, and improvisational. The genesis of the gates is found in a sketch of a pair of coils at the top of calligraphic horizontals and verticals. The presentation drawing in graphite and watercolor on paperboard indicates a lively swirling pattern of serpentine tapered bars (cat. no. 3). The eight-foot gates (pl. 1) took Paley and an assistant one year to complete, using sledgehammers and simple forming tools. Today, he could have made them more expeditiously, using power-driven hammers, lathes, and pressing machines. To celebrate its twentieth anniversary, the Renwick invited Paley to draw the gates once more (frontispiece). In this rendering, Paley used lines of varying thicknesses to reveal depth and layering and to accent mass, volume, and detail.

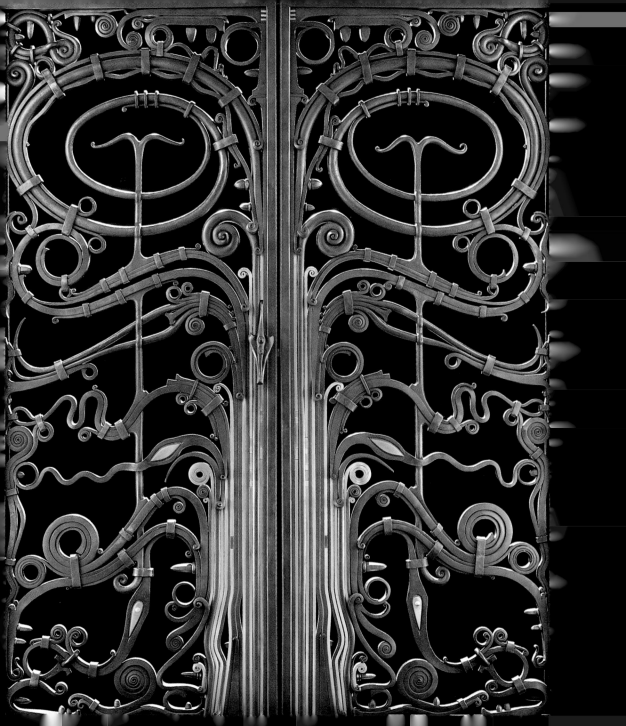

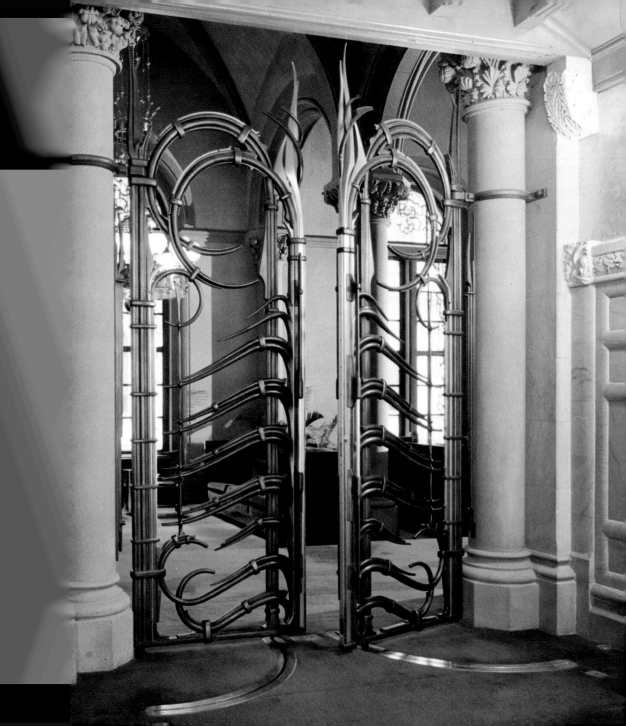

Close in material and technique to the Renwick gates are two
pairs of steel, brass, and bronze portal gates completed in 1980 for the
entry to the New York State Senate Chamber of the State Capitol in
Albany, New York, built by Henry Hobson Richardson and completed
in 1886. Here, again, the architectural setting is opulent, comprised of
massive stonework and brilliant stained glass beneath a vaulted ceiling.
"I could have designed gates that were simply functional," Paley recalls,
"but I wanted them to enhance the architecture, to symbolize the rites of
passage, and to speak in a spiritual sense of the formality and dignity of
government." The gates soar toward the ceiling, their ribs echoing the
ribs of the vault. At 13$^{1}/_{2}$ feet high, they are the largest forged pieces
Paley has done. Aided by seven assistants, Paley took one year to finish
the work. The gates as forged (pl. 2) are even more elegant, subtle, and
refined than they are in the final drawing (cat. no. 8).

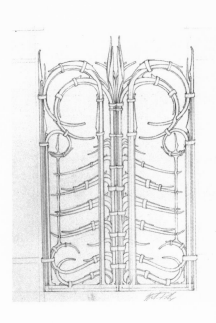

Today, few patrons of the arts are interested in funding major public sculptures. The Central Park Zoo in New York City, renovated in 1988, was to have been immeasurably enriched by a gate enclosed within a ceremonial archway that could well have been one of Paley's finest works, had the expected private financial contribution materialized. Paley brought the project, which would have been the first figurative piece he had done, as far as the partial-model stage (pl. 3). He developed two alternative proposals to be constructed in Cor-Ten steel with gold-leaf accents. The first keeps the existing brick pillars and walls in place, infilling them with a few large animals against a background of vinelike forms (cat. no. 14). By eliminating the masonry, the final design allows more space for a denser scheme in which flora and fauna intertwine (cat. no. 15). On the left is a jungle habitat, and to the right is an aquatic scene with sea creatures and water lilies. Paley had intended to exploit the many textures of worked-metal surfaces. Hammer and grinding marks were to become the scales of fish, the veins of leaves, the feathers of birds. Paley's ribbon shapes, used to suggest water, appear for the first time. The animals, made of quasi-three-dimensional plate steel bowed in relief on each side, resemble antique tin toys. "On top of the archway, I planned to put forged-steel pigeons," Paley relates. "The regular park pigeons would sit right up there with them."

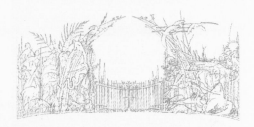

10

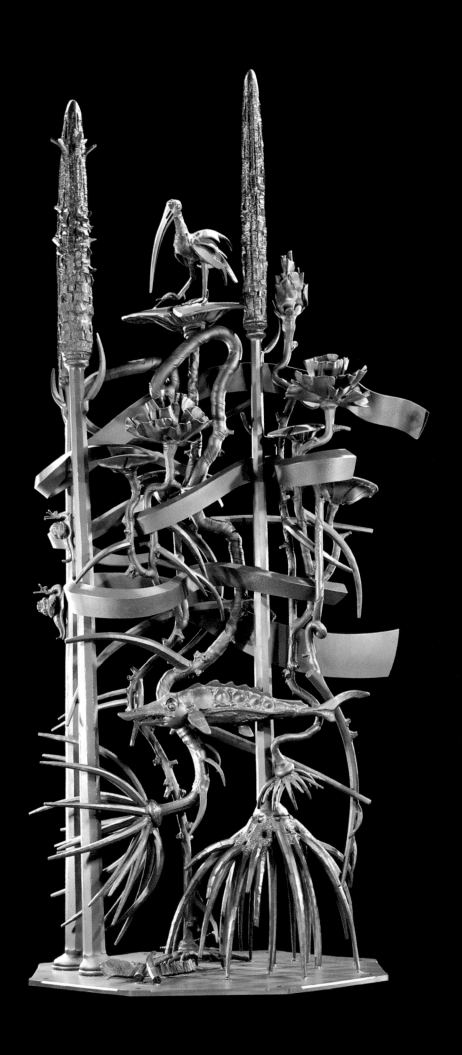

Plate 4.

Main Street Bridge Railing, 1988. Painted steel,
each 42 x 360 x 18 in. (167 x 914 x 46 cm).
Rochester, N.Y. Photograph: Bruce Miller

Each segment of a Paley work is individually shaped and welded.
Repetitive stamping or casting plays no role in the process. For example,
the 260-foot-long bridge railings of forged, fabricated, and painted steel
made in 1989 for the city of Rochester consist of individual pieces cut
from steel plate that were hydraulically bent, ground, forged, and welded.
When crafted, the segments of the Y-shaped forms were widened and
simplified (pl. 4). Paley says the railings are "like a woven steel lattice.
Even though the railings are basically flat, I wanted to emphasize their
three-dimensional nature." Cat. no. 21 was the last in the design devel-
opment series. The final full-scale drawing from which the railings were
fabricated, made on the wall of the shop, no longer exists.

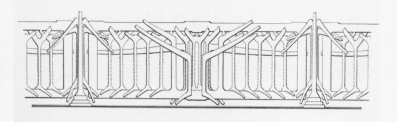

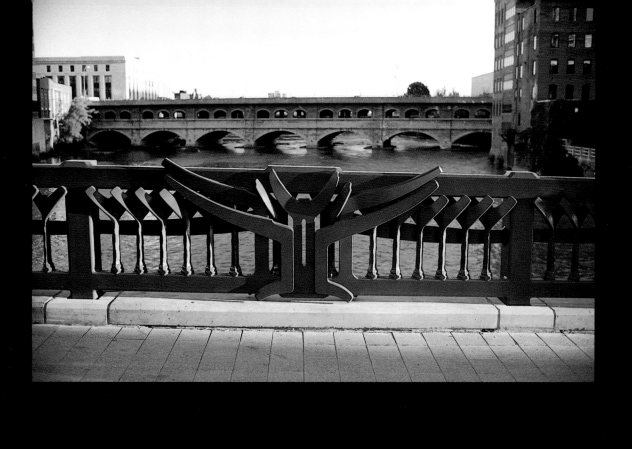

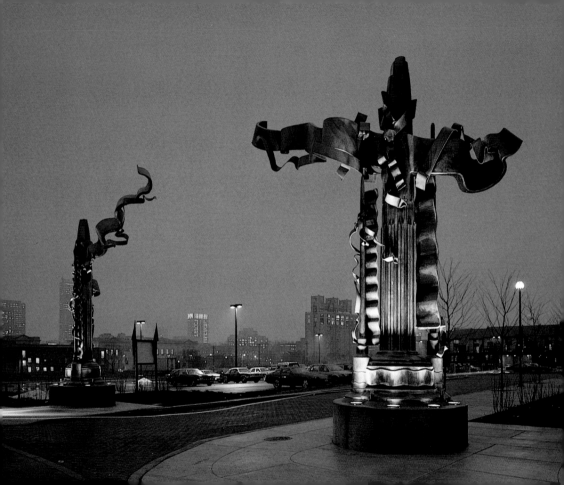

Plate 5.

Synergy, 1987. Painted steel, 300 x 648 x 36 in. (762 x 1646 x 91 cm).
Museum Towers, Philadelphia, Pa. Photograph: Tom Crane

In 1987, Paley completed one of his first large freestanding

public sculptures. *Synergy* consists of two identical painted steel pieces,

twenty-five feet high and six-feet wide, placed sixty feet apart on

opposite sides of the street entrance to Museum Towers, a mixed-use

development project in Philadelphia designed by Salkin Group, Inc., a

local architectural firm, and sponsored by the Redevelopment Authority

of the city. Taken together, the pair interrelate as a gateway to the project

(pl. 5). Paley's initial drawings of plant forms—clusters of sinewy, veined,

and striated shapes (cat. no. 19)—finally coalesce into the disciplined

flutings ornamenting the rocketlike pylons that support Paley's signa-

ture flying ribbons (cat. no. 20). "When I think of a structural column,"

Paley explains, "I think of something that rises from the ground. It is

analogous to the growth process of a plant. If you look at the branch of

a tree, it explains its own evolution. If you look at the base of a classical

stone building, you have rusticated base blocks, above them the various

bandings going around the building, and at the top, your richest orna-

ment and finest detail." The sides of the pylons are slightly bowed in a

"muscular" manner, as Paley describes it. "They flex themselves instead of

just cutting into space. They have resilience."

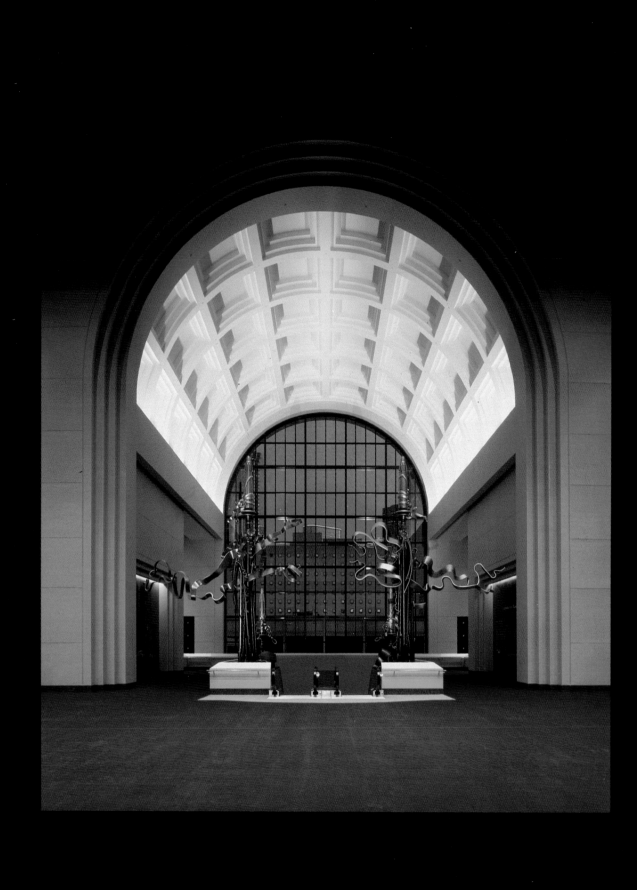

Eight beribboned, painted steel pylons were completed in 1987 for the Wortham Center for the Performing Arts in Houston, designed by Morris Architects (pl. 6). Four pairs of pylons line either side of the lobby's grand escalator. They graduate in height from fifteen feet at the bottom to thirty feet at the top, becoming more elaborate and flourishing as they rise. "This was the first time I used clusters of pod-capped staves wrapped with flying ribbons in an architectural setting," Paley remembers. "Because it is an opera house with a grand vaulted lobby, I wanted to turn the escalator into a triumphant ceremonial passage. The ribbons cantilever as far as twenty feet, flowing from right to left across the steps as though the building's energy, its architectural space, determined it. In the center of the escalator, the ribbons meet in a theatrical gesture from one sculpture to another." Required drawings were few. Paley took all his measurements for the pylons from the presentation drawing made for each size and went directly into fabrication. Cat. no. 17 is the final study for the thirty-foot pylons.

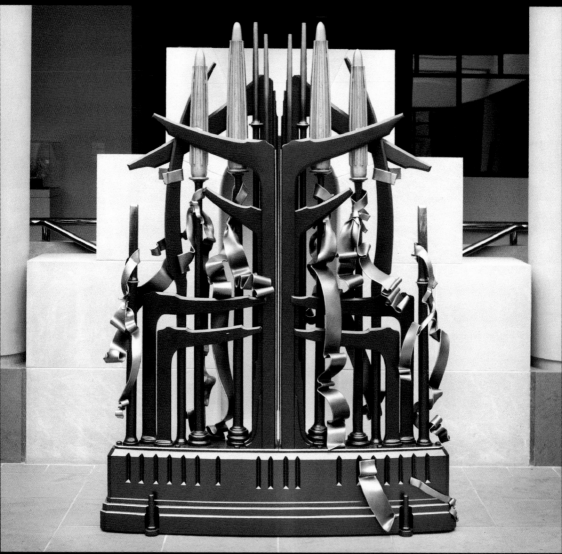

Convergence, an eight-foot-high interior sculpture of forged and fabricated painted steel, was created in 1988 as an architectural screen for a narrow passageway at the Memorial Art Gallery of the University of Rochester (pl. 7). Paley made it at the height of his interest in pod-capped staves wrapped in billowing ribbons. The diagonal forms branching upward and downward from the center frame relate to the ziggurat-shaped arched entrance to the passageway. Cat. no. 25 embodies a graphic style that Paley frequently uses to render the final stage of a design before fabrication. "It is quite stylized," he admits. "I use varied line weights to give a sense of dynamism. Starting from the central axis, of the piece, every segment to the right is accented by increasing the line weight defining its right edge. For the segments to the left of the axis I do the opposite. I also use a heavy line in delineating the underside of forms to indicate a response to gravity." At the first stage of fabrication, he magnified the drawing to actual scale using an opaque projector and transferred it in sections to large pieces of paper. Further full-size studies and notations were made on these enlargements.

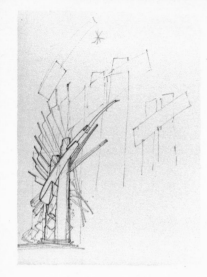

When Paley begins to imagine a large-scale sculpture for an architectural setting, he addresses two formal issues: how his work will complement and amplify the building and the landscape, and how it will relate to pedestrians. "Few of the big impersonal sculptures plopped in front of buildings make direct, intimate contact with passersby," he notes. These issues are successfully resolved in *Olympia,* a sculpture formed and fabricated in polychromed steel in 1990 for the Landmarks Group, Promenade II Building, in Atlanta, designed by Thompson, Ventulett, Stainback and Associates, Inc. (pl. 8). Paley's final concept drawing (cat. no. 41) indicates an immense work—twenty-nine feet high, twelve feet wide, and six feet deep—centrally located in a plaza opposite a building of thirty stories sheathed in grayish pink granite. "The great vertical thrust of the skyscraper made me want to create sculpture that appears to defy its own weight," Paley explains. "I wanted it to be a kind of updraft, to look as though it were being pulled up by the upward force of the building. I wanted the piece to appear to have no structural integrity. The material is heavy-gauge steel, but I made it look as though it is defying its physical nature and existing unfettered by its own constraints. The individual elements are all separate, they splay apart in a fanlike shape and unfurl in many directions. I think of it as time-lapse photography, frozen motion, or as Marcel Duchamp's *Nude Descending a Staircase.* It is a progression, as one form begets another form. The tumbling cubes that appear to be falling out of the composition energize the space for the pedestrian." Because the building for which *Olympia* is the focus appears to Paley as "massive, omnipresent, and monochromatic," he painted the work in bright, almost primary, colors.

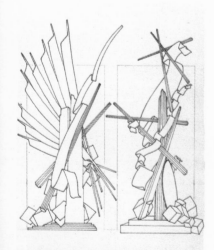

Plate 8.
Olympia, 1990. Painted steel, 360 x 144 x 96 in. (914 x 366 x 244 cm). Promenade II Building, Atlanta, Ga. Photograph: John Dale

20

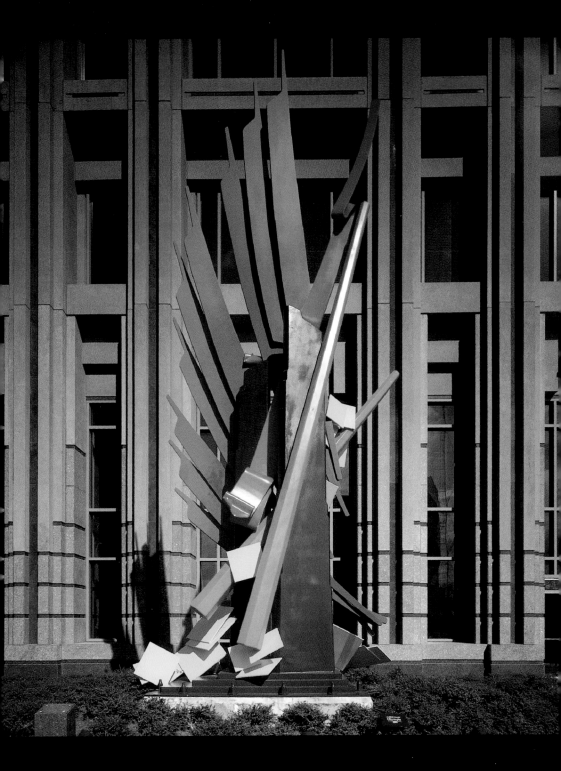

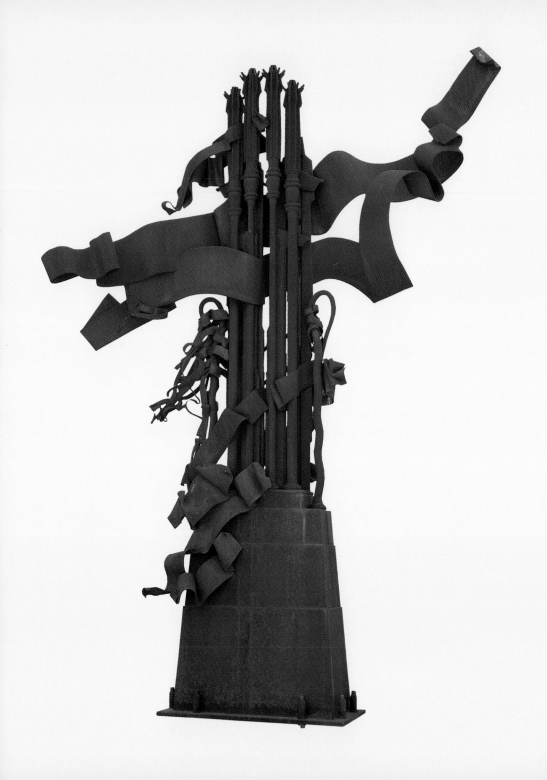

Plate 9.

Confluence, 1990. Cor-Ten steel, 198 x 138 x 67 in. (503 x 351 x 170 cm).
Birmingham Museum of Art, Ala. Commissioned with funds provided by
Mr. and Mrs. Charles W. Ireland and the Acquisition Fund, Inc. (AFI 1.1986).
Used by permission of the Birmingham Museum of Art

The completion in 1990 of *Confluence,* an exterior piece formed
and fabricated in Cor-Ten steel (pl. 9), required more drawings than usual
for Paley (cat. nos. 28–32). Designed for the sculpture court of the Bir-
mingham Museum of Art, Alabama, the work is to be looked up at, from
a shoulder-high plinth. Another study in pod-capped staves and flowing
ribbons, this eighteen-foot-high piece has banners that cascade down-
ward, spilling over the plinth toward the viewer. "I did several proposals,"
Paley recalls. "I wanted to deal with verticality and intimacy, and all the
drawings are configurations of those themes. They are very sketchy and
don't resemble structures or individual elements but instead are like an
artist's cross-hatching as a means to suggest mass and proportion, or
almost like scribbling. After all these indistinct lines give me the feel-
ing, the sense of balance, the sense of motion, I start to detail the form.
I have my own lexicon of form, but it is always rooted in this sketchy
matrix. There is a genuine interplay between the graphic images and
the developing concept of the piece. It seems as I begin to interpret the
lines that I have so casually put down, they develop form on their own."

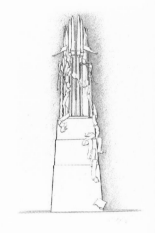

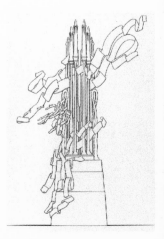

The ultimate meaning of a sequence of Paley drawings—from conceptual sketches, through design development, to final rendering—is to be found in its outcome: a work in metal, wrought with consummate skill. Few contemporary sculptors in the United States creating large-scale designs in metal fabricate their own works. The usual practice is to create a clay or plaster maquette that is transformed into metal at an independent foundry. Whatever the means of fabrication, however, mastery of craft always fascinates and beguiles. One marvels at Paley's invisible joinery, his variety of hammered textures, his silky glosses. One is entranced by his ability to transform a material as obdurate and heavy as iron into ribbons that ripple in the air, into sinuous tendrils that appear to grow, or into interlocking abstract forms in a multitude of shapes that seem barely to touch, yet magically suspend themselves and one another in space.

More significant than Paley's mastery of technique, however, is the fact that his work, in content as well as form, is so different from what everyone else is doing. Among today's artists, he alone has set himself the momentous and timely task of reinventing the art and craft of sculpture and ornament so that these once expected and familiar embellishments may again truly enhance architecture and its landscape. If his influence spreads, it will forever change the way we look at and think about architecture and its enriching arts.

Mildred F. Schmertz

Contributing Editor, *Architecture*

24

Catalogue of the Exhibition

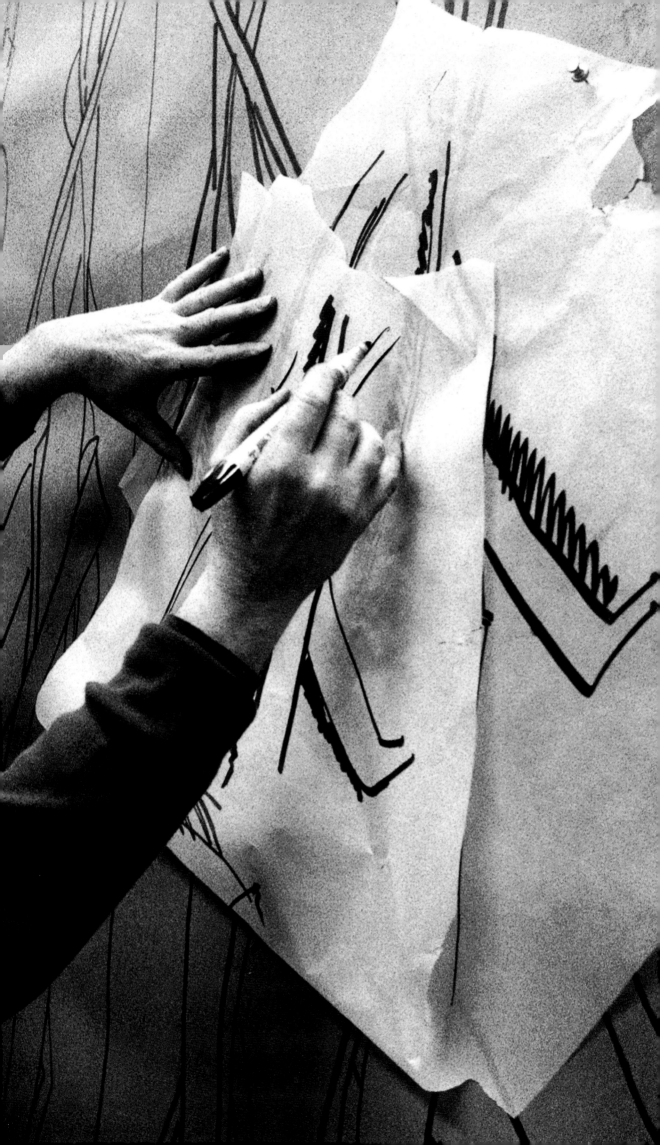

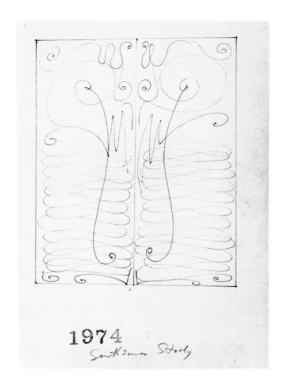

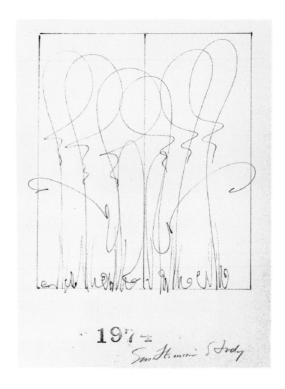

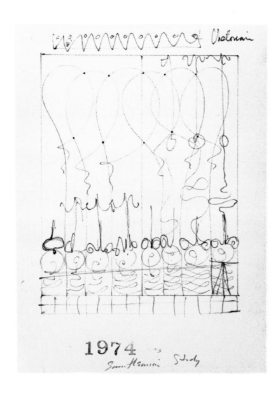

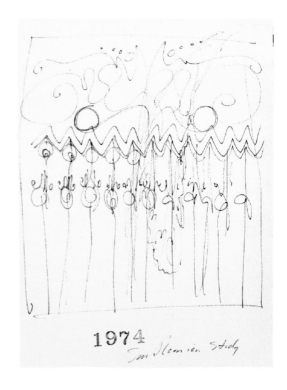

1.

Studies for the Portal Gates for the Renwick Gallery, 1972.
Ink on paper, each 12 x 9 in. (30 x 23 cm).
Collection of the artist (GA 72.1.2, .3, .5, .7)

3.
Presentation Drawing for the Portal Gates for the Renwick Gallery, 1972.
Graphite and watercolor on paperboard, 20 x 15 in. (51 x 38 cm).
National Museum of American Art, Smithsonian Institution, Washington, D.C. (1975.117.2)

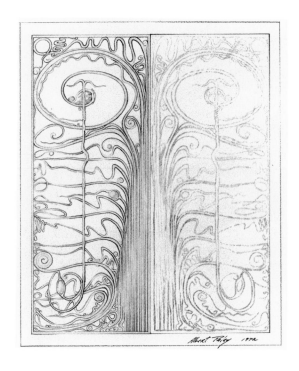

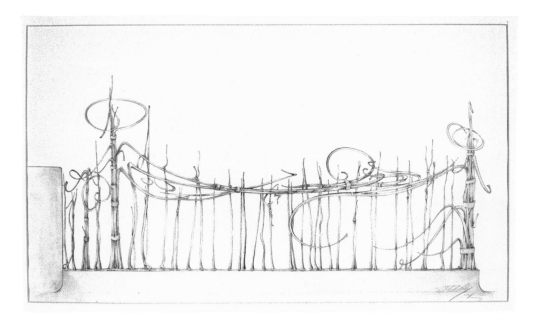

4.
Working Sketch for the Hunter Museum Fence: Section II, 1974.
Graphite, ink, and ink wash on paper, 17¼ x 33 in. (44 x 84 cm).
Hunter Museum of Art, Chattanooga, Tenn., museum commission (HMA 1975.1.b)

5.
Working Sketch for the Hunter Museum Fence: Section III, 1974.
Graphite, ink, and ink wash on paper, 20 x 22 in. (51 x 56 cm).
Hunter Museum of Art, Chattanooga, Tenn., museum commission (HMA 1975.1.c)

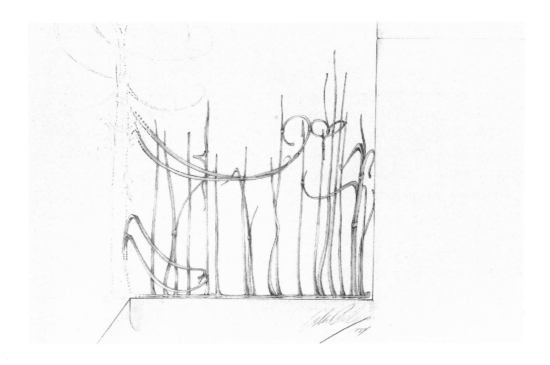

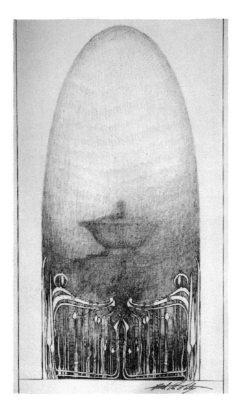

6.
Proposal Drawing for the Smithson Crypt Gate, 1975.
Graphite on illustration board, matted, 30 x 20 in. (76 x 51 cm).
Smithsonian Institution, Washington, D.C., Archives (S12/I10)

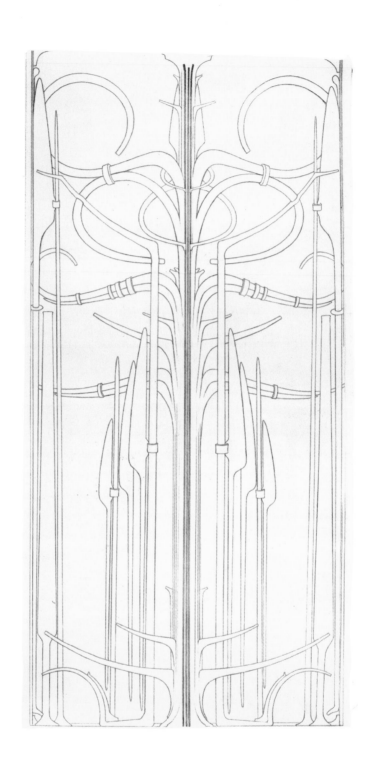

7.
Gate Proposal, 1978.
Graphite on paper, 82¹/₄ x 42 in. (209 x 107 cm).
Collection of the artist (GA 78.1)

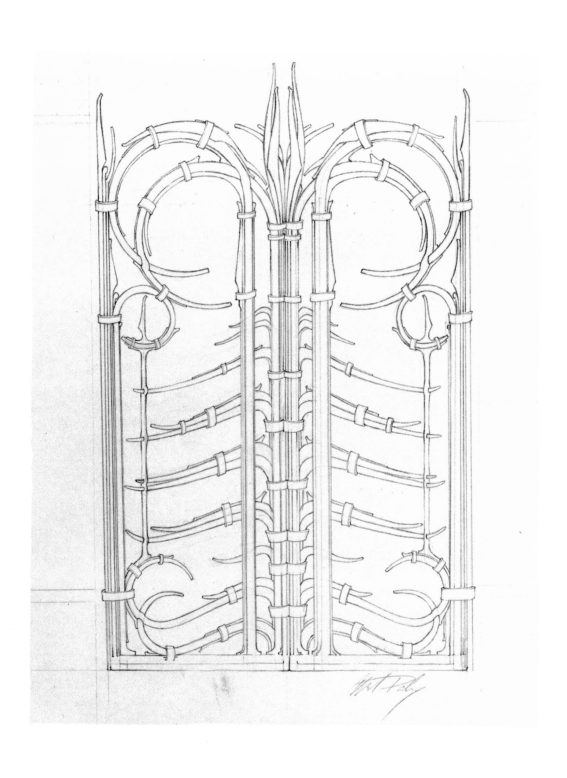

8.
Proposal for the Portal Gates for the New York State Capitol, Albany, 1978.
Graphite on paper, 13³/₄ x 11 in. (35 x 28 cm).
Collection of the artist (GA 78.5)

9.

Proposal for a Tree Grate for Pennsylvania Avenue, Washington, D.C., 1979.
Graphite on paper, 31^1/$_2$ x 24 in. (80 x 61 cm).
Collection of the artist (AO 79.1)

10.

Proposal for an Entrance Gate for a Private Residence, Washington, D.C., 1980.
Graphite on paper, 29 x 23 in. (74 x 59 cm).
Collection of the artist (GA 80.1)

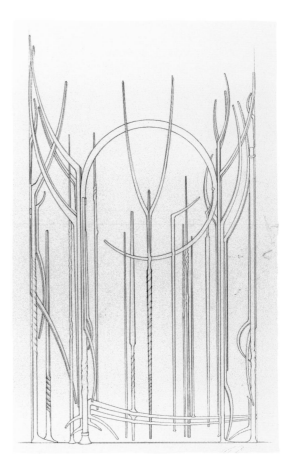

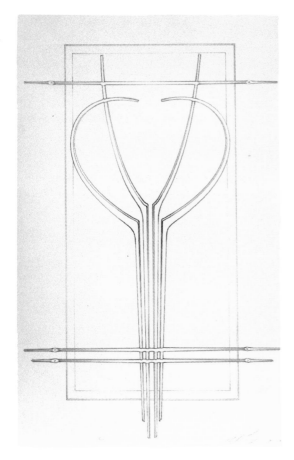

11.

Proposal for a Window Grill for a Private Residence, Rochester, New York, 1980.
Graphite on paper, 23 x 14¹/₂ in. (59 x 37 cm).
Collection of the artist (SCR 80.1)

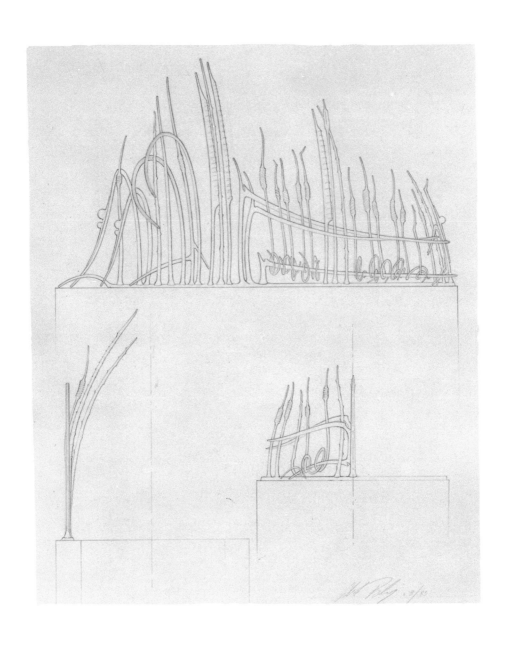

12.

Preliminary Elevations of Ironwork for a Stairwell Enclosure, Hyatt Regency Grand Cypress Hotel, Orlando, Florida, 1983.
Graphite on paper, 29 x 23 in. (74 x 59 cm).
Metropolitan Museum of Art, N.Y., Purchase, Grand Cypress Hotel Corporation,
a subsidiary of Dutch Institutional Holding Company, Gift (1990.1021)

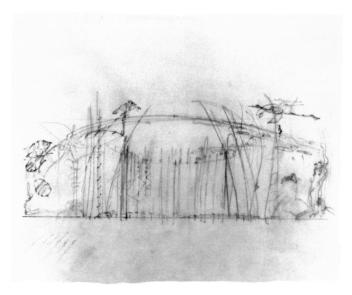

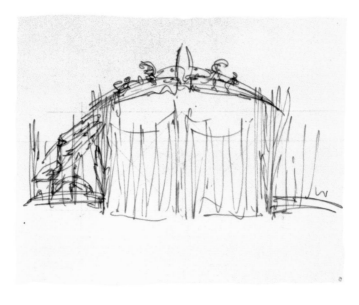

13.
Sketches for the Central Park Zoo Gate, ca. 1983.
Ink and graphite on tracing paper, each approx. 14 x 16³/4 in. (36 x 43 cm).
Collection of the artist (GA 83.1.2, .3, .5)

14.
Proposal for the Central Park Zoo Gate, 1983.
Graphite on paper, 30 x 40 in. (76 x 102 cm).
Collection of the artist (GA 83.2)

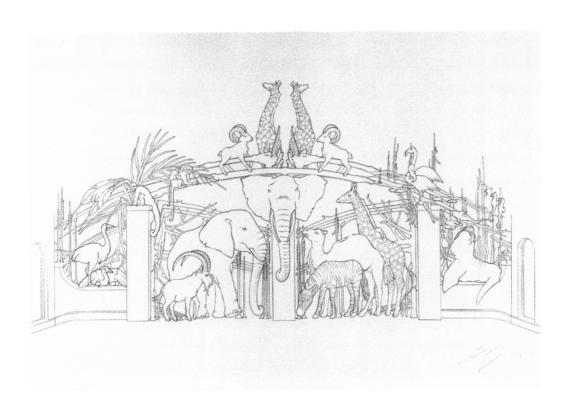

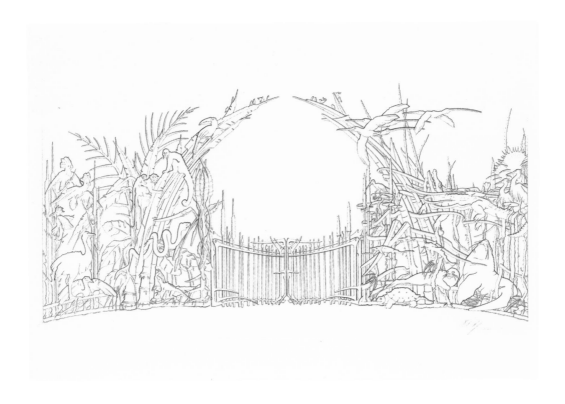

15.
Final Proposal for the Central Park Zoo Gate, 1985.
Graphite on board, 30 x 40 in. (76 x 102 cm).
Collection of the artist (GA 85.2.1)

16.

Proposal for a Window Screen for a Private Residence, California, 1985.
Graphite on paper, 23 x 29 in. (59 x 74 cm).
Collection of the artist (SCR 85.1)

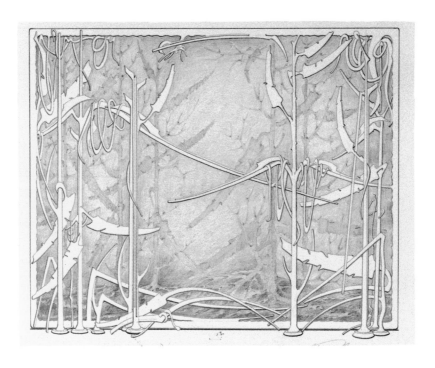

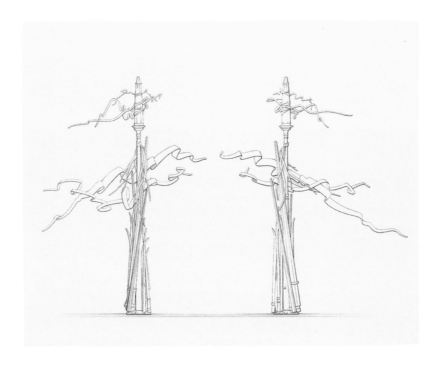

17.

Proposal for a Sculpture for the Wortham Center for the Performing Arts, Houston, Texas: Top Level, 1985.
Graphite on paper, 23 x 29 in. (59 x 74 cm).
Collection of the artist (SCU 85.4)

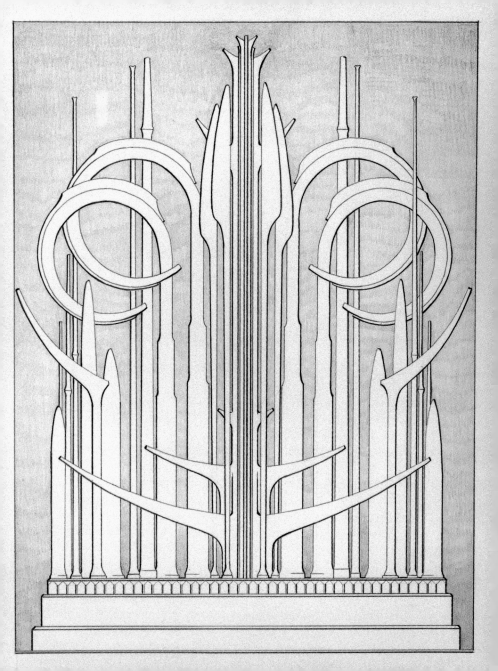

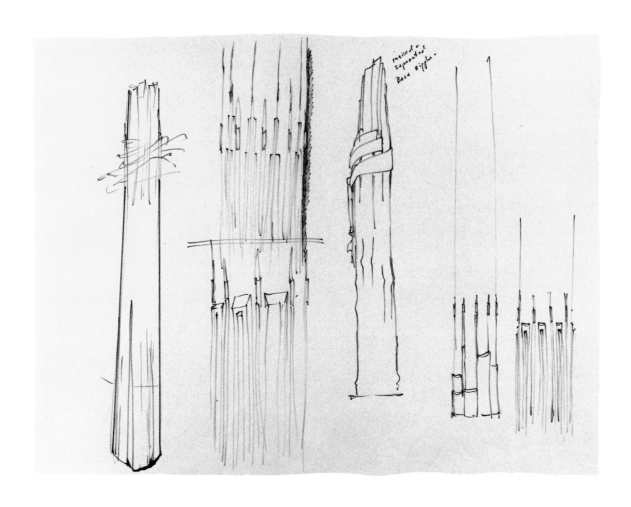

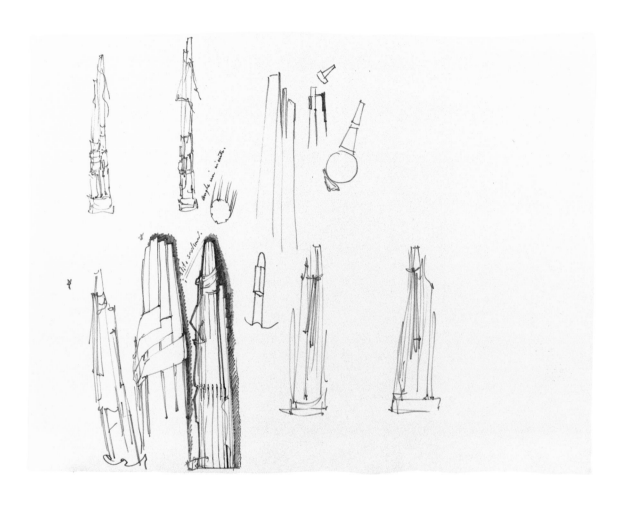

19.
Sketches for Synergy, an Archway Sculpture for Museum Towers, Philadelphia, Pennsylvania, 1986.
Blue felt-tip marker on paper, each 18 x 24 in. (46 x 61 cm).
Collection of the artist (AF 86.1.3, .4)

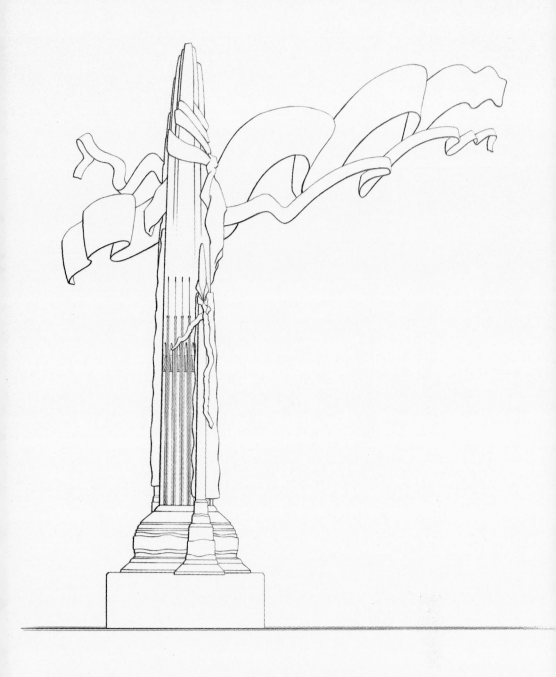

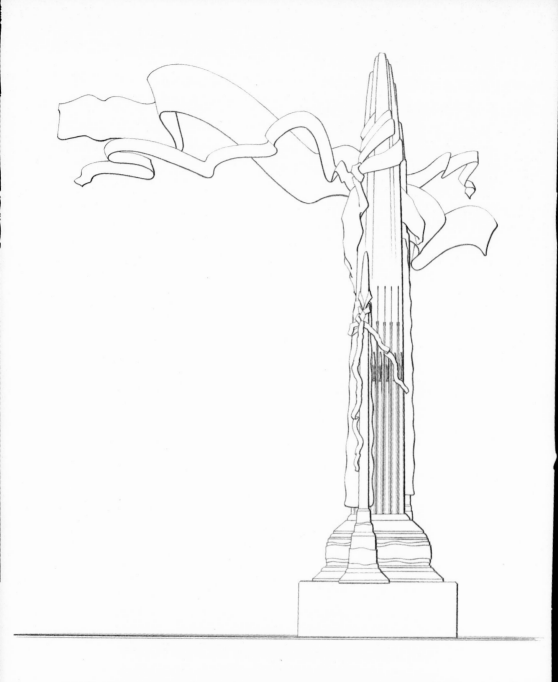

20.
Proposal for Synergy, an Archway Sculpture for Museum Towers, Philadelphia, Pennsylvania, 1986.
Graphite on paper, each 29 x 23 in. (74 x 59 cm).
Collection of the artist (AF 86.2, .3)

21.
Proposal for the Main Street Bridge Railing, Rochester, New York, 1987.
Graphite on paper, 23 x 29 in. (74 x 59 cm).
Collection of the artist (RLG 87.1)

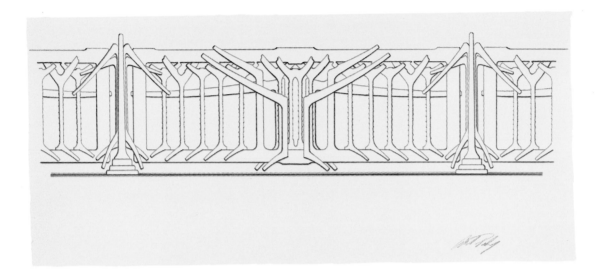

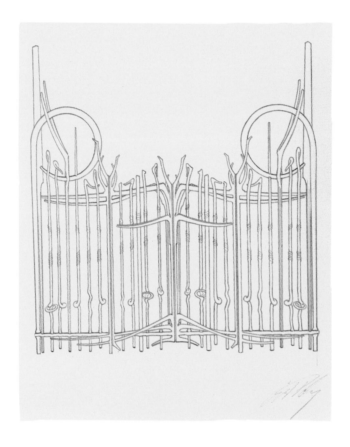

22.
Proposal for the Plaza Gate, Milk Street Station, Massachusetts Bay Transportation Authority, Boston, 1987.
Graphite on paper, 19¹/₂ x 20³/₄ in. (50 x 53 cm).
Collection of the artist (GA 87.1)

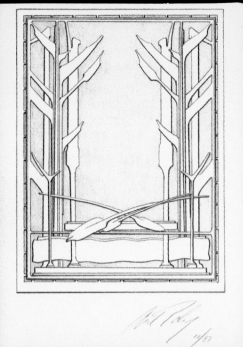

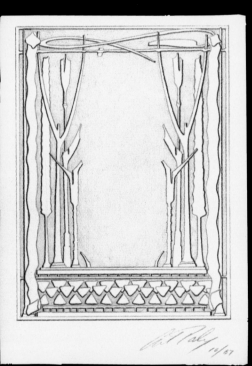

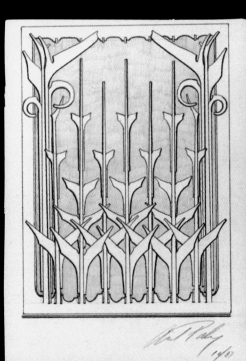

23.
Proposals for Screens for the Lasdon Biomedical Research Center,
Cornell University Medical College, New York, 1987.
Graphite on paper, each 11 x 8$^{1}/_{2}$ in. (28 x 22 cm).
Collection of the artist (SCR 87.8, 87.9.1, 87.10, 87.11.1)

24.

Study for a Wall Sconce for the Washington Hebrew Congregation, Washington, D.C., 1987.
Graphite on oaktag, 29¹/₂ x 20 in. (75 x 51 cm).
Collection of the artist (LT 87.3.2)

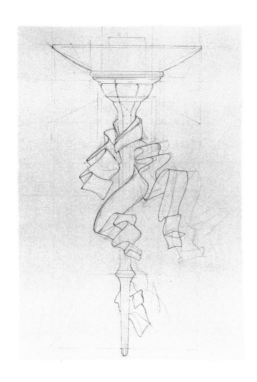

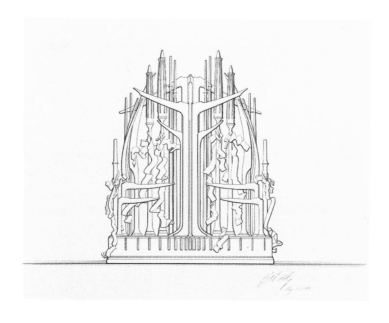

25.

Proposal for Convergence, 1987.
Graphite on paper, 23 x 29 in. (58 x 74 cm).
Memorial Art Gallery of the University of Rochester, N.Y. (92.40)

26.
Proposal #1 for the Memorial Gate, Ackland Art Museum,
University of North Carolina at Chapel Hill, 1988.
Graphite on paper, 23 x 29 in. (58 x 74 cm).
Collection of the artist (GA 88.1.1)

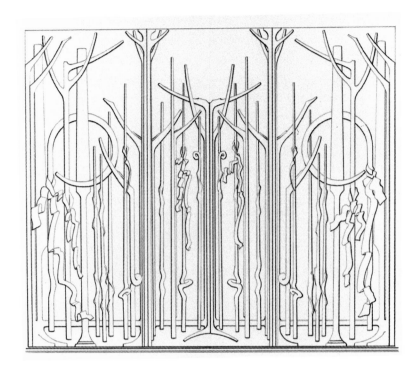

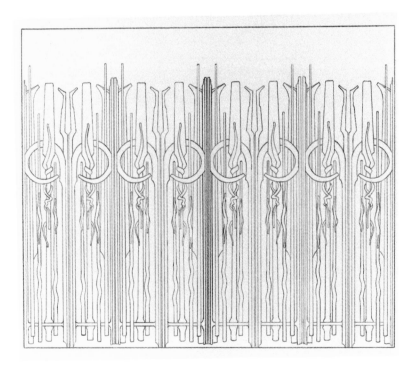

27.
Proposal #2 for the Memorial Gate, Ackland Art Museum,
University of North Carolina at Chapel Hill, 1988.
Graphite on paper, 23 x 29 in. (58 x 74 cm).
Collection of the artist (GA 88.2.1)

28.
Studies for Confluence, Birmingham Museum of Art, Alabama, 1988.
Graphite and colored pencil on paper, 13^1/$_2$ x 10^1/$_2$ in. (34 x 27 cm).
Collection of the artist (SCU 88.1.2)

29.
Studies for Confluence, Birmingham Museum of Art, Alabama, 1988.
Graphite on paper, each approx. 6 x 2¼ in. (15 x 6 cm).
Collection of the artist (SCU 88.1.3)

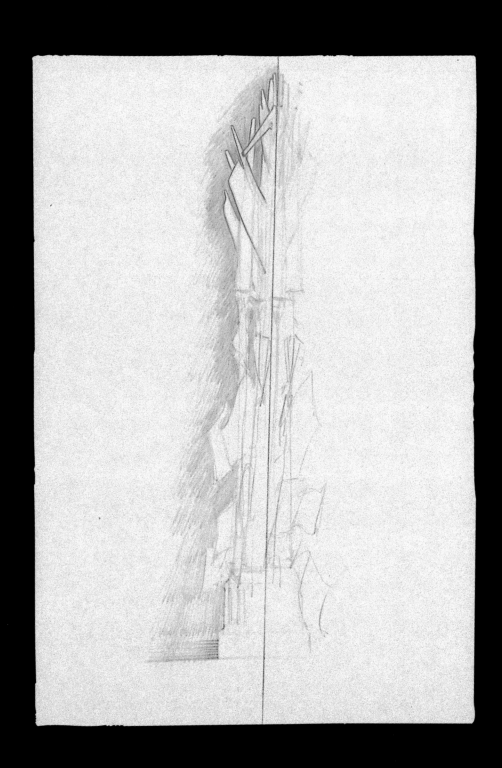

30.
Study for Confluence, Birmingham Museum of Art, Alabama, 1989.
Graphite and colored pencil on paper, 13^{1}/$_{2}$ x 9 in. (34 x 23 cm).
Collection of the artist (SCU 88.2.2)

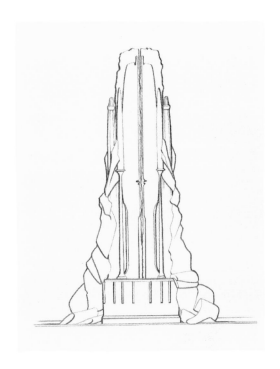
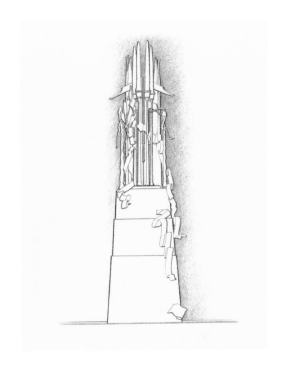
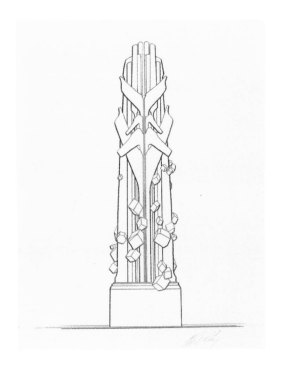
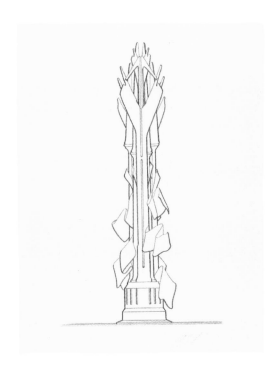

31.
Proposals for Confluence, Birmingham Museum of Art, Alabama, 1988.
Graphite on paper, each 12 x 9 in. (30 x 23 cm).
Collection of the artist (SCU 88.1, .2, .3, .7)

32.
Proposal for Confluence, Birmingham Museum of Art, Alabama, 1989.
Graphite on paper, 29 x 23 in. (74 x 58 cm).
Collection of the artist (SCU 89.2.1)

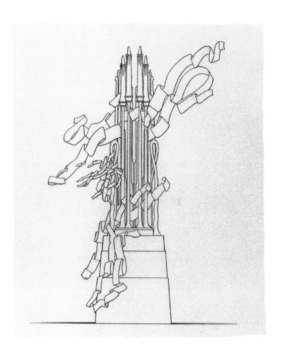

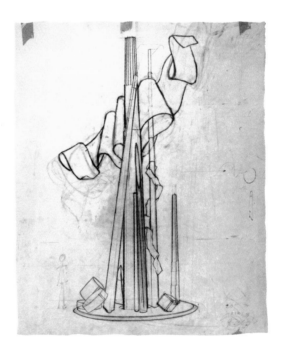

33.
Study for Aurora, Charlotte Coliseum, North Carolina, 1989.
Graphite on oaktag, 29 x 23 in. (74 x 58 cm).
Collection of the artist (SCU 89.4.2)

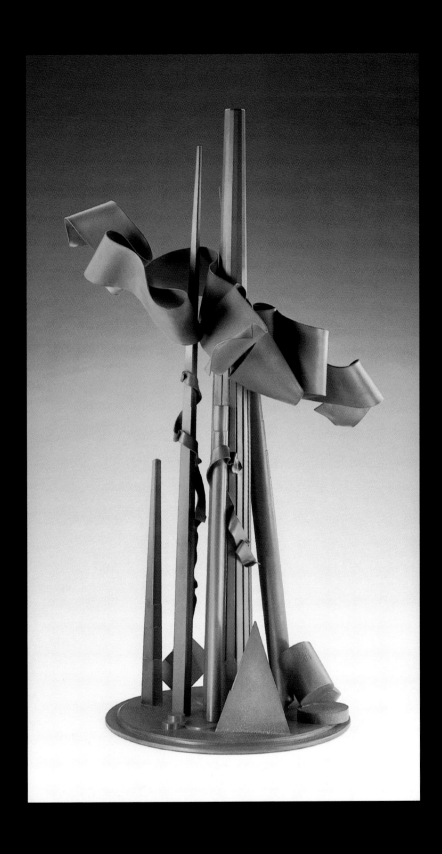

34.
Proposal Maquette for Aurora, Charlotte Coliseum, North Carolina, 1989.
Steel, dia. 53 x 28 in. (135 x 71 cm).
Paley Studios Ltd., Rochester, N.Y. (PM-1)

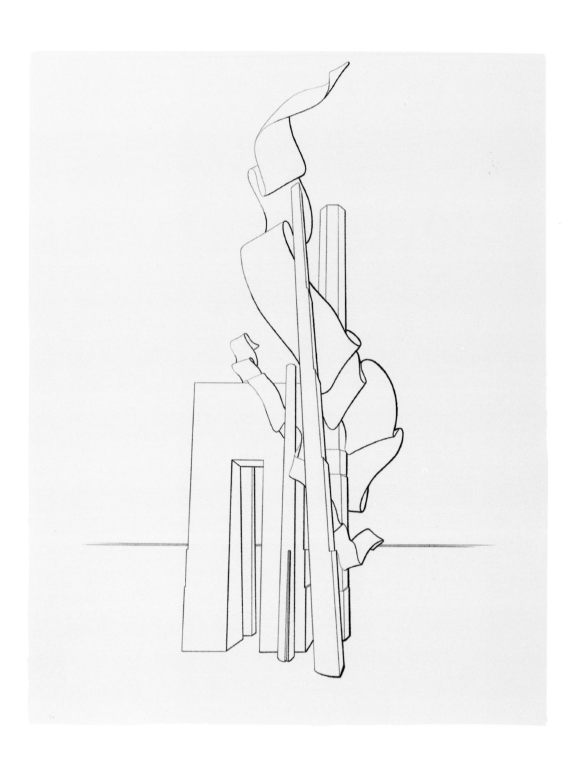

35.
Proposal for a Plaza Sculpture, Boston, Massachusetts, 1989.
Graphite on paper, 29 x 23 in. (74 x 58 cm).
Collection of the artist (SCU 89.7.1)

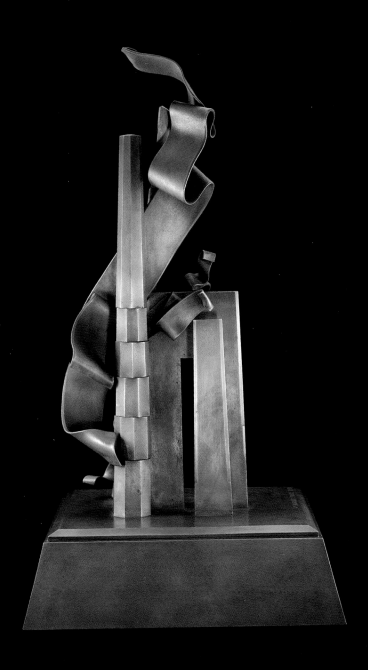

36.
Proposal Maquette for a Plaza Sculpture, Boston, Massachusetts, 1990.
Copper-plated steel, 28 x 15 x 13 in. (71 x 38 x 33 cm).
Paley Studios Ltd., Rochester, N.Y. (PM-3)

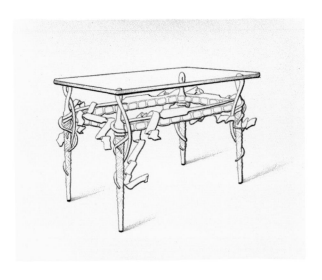

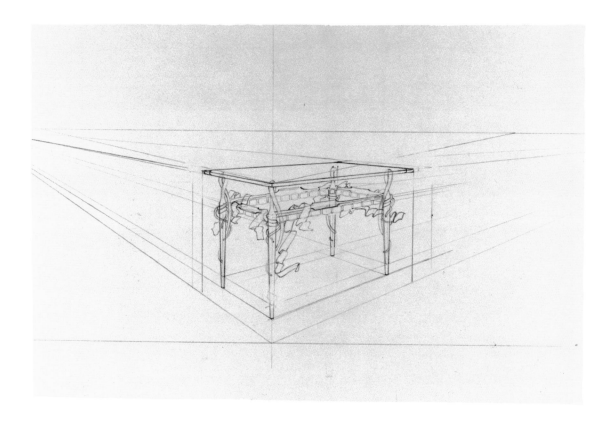

37.
Commission for a Sideboard for the Yale University Art Gallery, 1989.
Graphite on paper, 10 x 13^{1}/$_{2}$ in. (25 x 34 cm), 9^{1}/$_{2}$ x 14^{1}/$_{2}$ in. (24 x 37 cm).
Collection of the artist (TAB 89.1.1, .2)

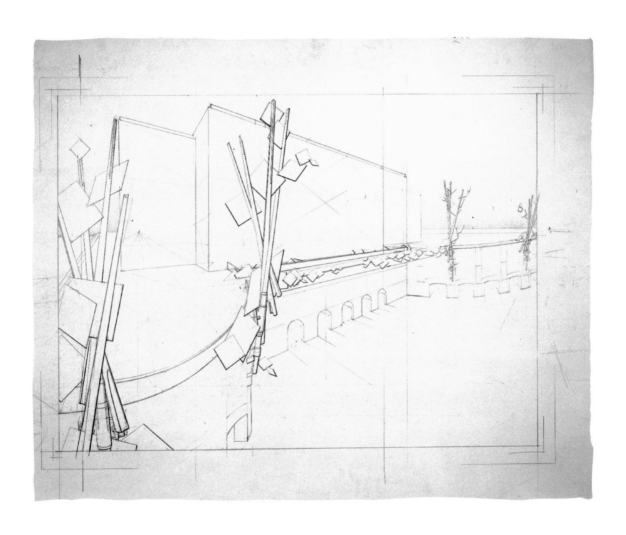

38.
Proposal for Plaza Sculptures and Bridge for the Rundel Library Expansion, Rochester, New York, 1990.
Graphite on paper, 32 x 45 in. (81 x 114 cm).
Collection of the artist (AF 90.4)

39.
Sketches for a Railing for a Private Residence, New York, 1990.
Graphite on oaktag, 24 x 36 in. (61 x 91 cm).
Collection of the artist (RLG 90.1.2)

40.

Studies for Olympia, Promenade II Building, Atlanta, Georgia, 1990.
Black felt-tip marker and colored pencil on paper, each 24 x 18 in. (61 x 46 cm).
Collection of the artist (SCU 90.1.2, .2)

41.

Proposals for Olympia, Promenade II Building, Atlanta, Georgia, 1990.
Felt-tip marker on oaktag, each 18 x 16 in. (46 x 41 cm).
Collection of the artist (SCU 90.1.1, 90.2.1)

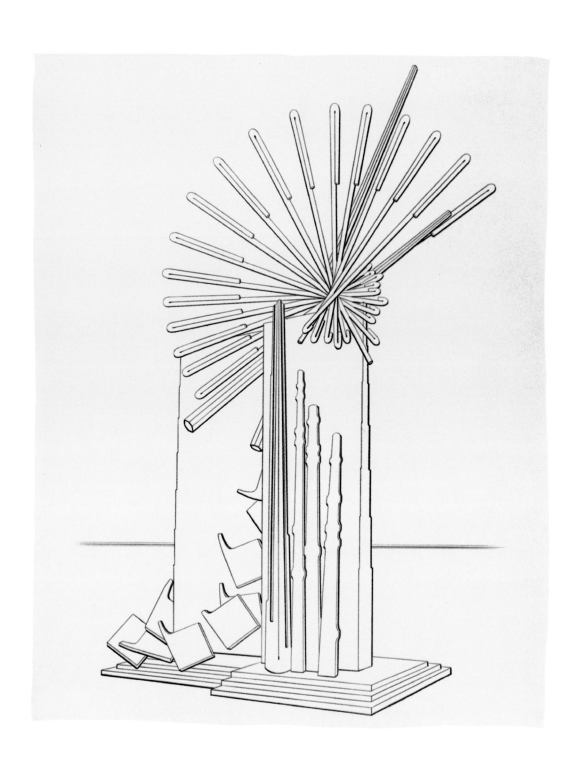

42.

Proposal for a Sculpture for the Greater Rochester International Airport, New York, 1990.
Graphite on paper, 29 x 23 in. (74 x 58 cm).
Collection of the artist (SCU 90.5.1)

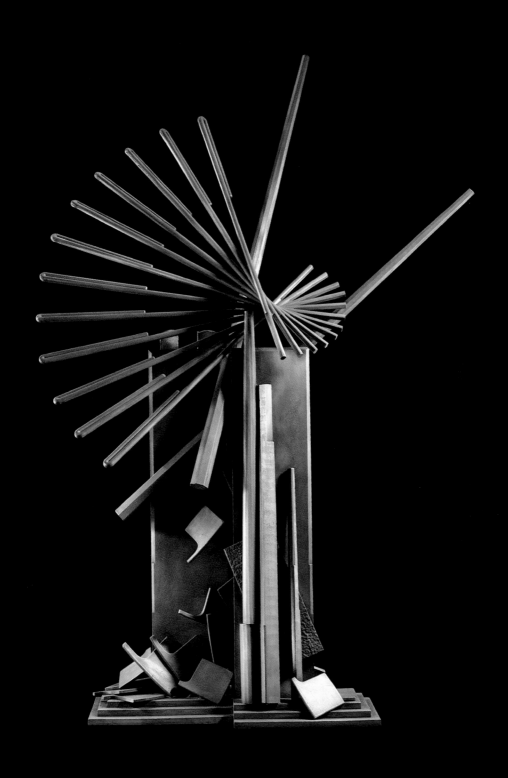

43.

Proposal Maquette for a Sculpture for the Greater Rochester International Airport, New York, 1991.

Copper-plated steel, 51 x 34 x 15 in. (130 x 86 x 38 cm).

Collection of Robert and Nancy Sands, Rochester, N.Y.

44.

Proposal #1 for the Ceremonial Gate, Arizona State University, Phoenix, 1991.
Graphite on paper, 29 x 23 in. (74 x 58 cm).
Collection of the artist (GA 91.1.1)

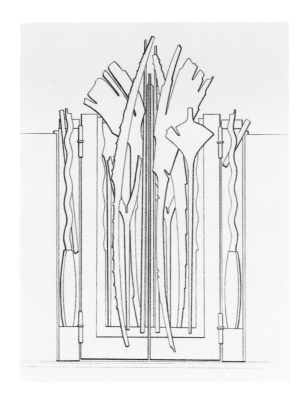

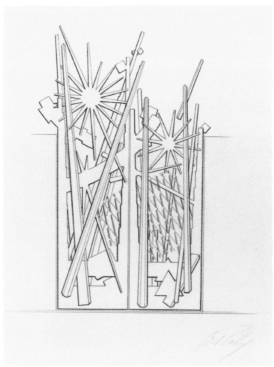

45.

Proposal #2 for the Ceremonial Gate, Arizona State University, Phoenix, 1991.
Graphite on paper, 29 x 23 in. (74 x 58 cm).
Collection of the artist (GA 91.3.1)

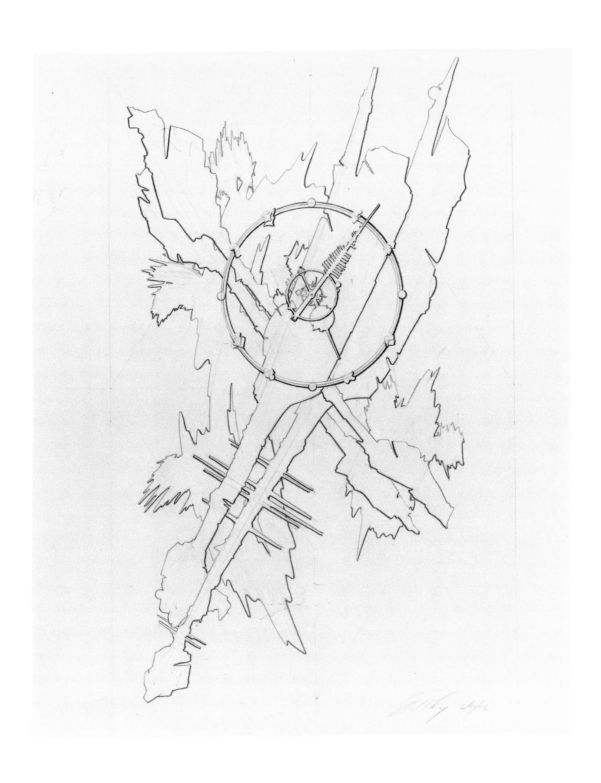

46.
Study for a Clock for the Grand Hall, Orlando Airport, Florida, 1992.
Graphite on oaktag, 24 x 22³/₄ in. (61 x 58 cm).
Collection of the artist (AO 92.1.1)

47.

Study for a Sculpture for the Reading Terminal Convention Center, Philadelphia, Pennsylvania, 1992.
Graphite and colored pencil on paper, 27^1/$_2$ x 76 in. (70 x 193 cm).
Collection of the artist (SCU 92.3.2)

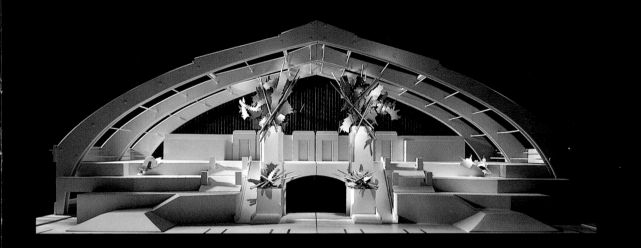

48.
Proposal Maquette for a Sculpture for the Reading Terminal Convention Center, Philadelphia, Pennsylvania, 1992.
Polychromed steel, 23¹/₂ x 66¹/₂ x 37¹/₂ in. (60 x 169 x 95 cm).

49.
Proposal for Sculpture Screens for the Federal Courthouse, Camden, New Jersey, 1992.
Graphite on vellum, 22 x 46¹/₄ in. (56 x 117 cm).
Collection of the artist (SCU 92.5.1)

50.

Sketches for the Tabernacle Screen, Temple Israel, Dayton, Ohio, 1993.
Graphite on paper, 22¹/₂ x 28¹/₂ in. (57 x 72 cm).
Collection of the artist (SCR 93.1.3)

51.

Proposal for the Tabernacle Screen, Temple Israel, Dayton, Ohio, 1993.
Graphite on paper, 22¹/₂ x 28¹/₂ in. (57 x 72 cm).
Collection of the artist (SCR 93.1.1)

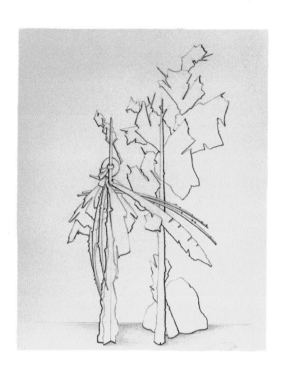 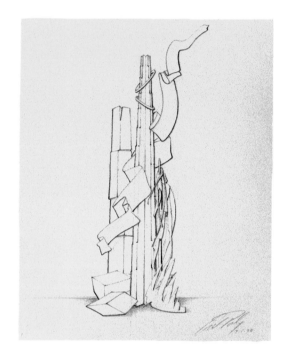

52.
Proposal for a Sculpture for Asheville, North Carolina, and for a Sculpture for an Athletic Complex, Japan, 1993.
Graphite on paper, each 14 x 11 in. (36 x 28 cm).
Collection of the artist (SCU 93.1, .2)

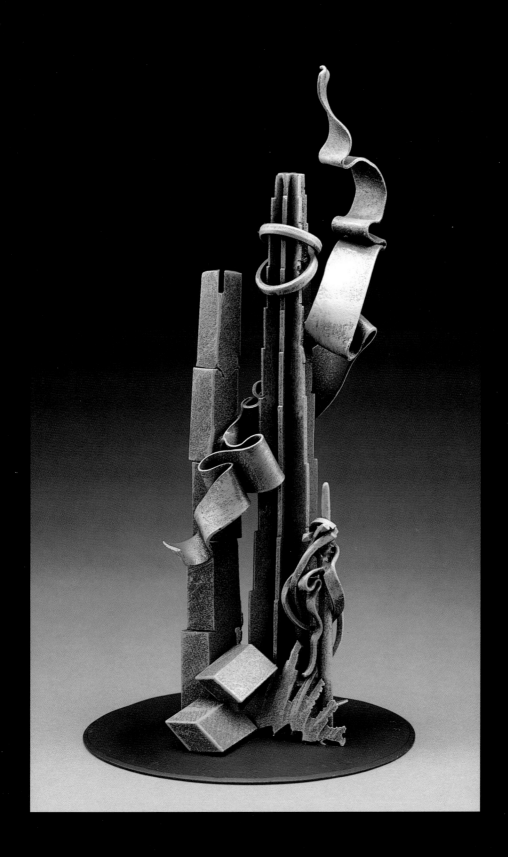

53.
Proposal Maquette for a Sculpture for an Athletic Complex, Japan, 1993.
Painted steel, dia. 10$^1/_2$ X 5$^1/_3$ in. (27 x 14 cm).
Paley Studios Ltd., Rochester, N.Y. (PM-8)

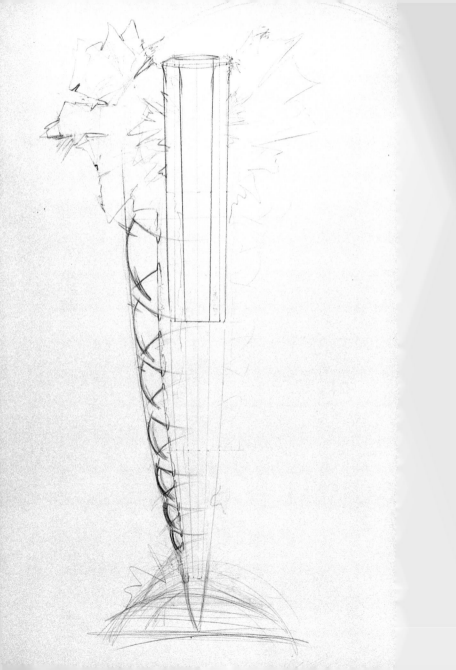

Catalogue of the Exhibition

Frontispiece

Reinterpretation of the Portal Gates for the Renwick Gallery, 1992. Graphite on paper, 48 x 35¹/₄ in. (122 x 90 cm). Collection of the artist (GA 92.1). Commissioned by the Renwick Gallery, National Museum of American Art, Smithsonian Institution, Washington, D.C., in observation of its twentieth anniversary

1. *Studies for the Portal Gates for the Renwick Gallery,* 1972. Ink on paper, each 12 x 9 in. (30 x 23 cm). Collection of the artist (GA 72.1.2, .3, .5, .7)

2. *Study for the Portal Gates for the Renwick Gallery,* 1972. Ink on board, 20 x 30 in. (51 x 76 cm). Collection of the artist (GA 72.1.18)

3. *Presentation Drawing for the Portal Gates for the Renwick Gallery,* 1972. Graphite and watercolor on paperboard, 20 x 15 in. (51 x 38 cm). National Museum of American Art, Smithsonian Institution, Washington, D.C. (1975.117.2)

4. *Working Sketch for the Hunter Museum Fence: Section II,* 1974. Graphite, ink, and ink wash on paper, 17¹/₄ x 33 in. (44 x 84 cm). Hunter Museum of Art, Chattanooga, Tenn., museum commission (HMA 1975.1.b)

5. *Working Sketch for the Hunter Museum Fence: Section III,* 1974. Graphite, ink, and ink wash on paper, 20 x 22 in. (51 x 56 cm). Hunter Museum of Art, Chattanooga, Tenn., museum commission (HMA 1975.1.c)

6. *Proposal Drawing for the Smithson Crypt Gate,* 1975. Graphite on illustration board, matted, 30 x 20 in. (76 x 51 cm). Smithsonian Institution, Washington, D.C., Archives (S12/I10)

7. *Gate Proposal,* 1978. Graphite on paper, 82¹/₄ x 42 in. (209 x 107 cm). Collection of the artist (GA 78.1)

8. *Proposal for the Portal Gates for the New York State Capitol, Albany,* 1978. Graphite on paper, 13³/₄ x 11 in. (35 x 28 cm). Collection of the artist (GA 78.5)

9. *Proposal for a Tree Grate for Pennsylvania Avenue, Washington, D.C.,* 1979. Graphite on paper, 31¹/₂ x 24 in. (80 x 61 cm). Collection of the artist (AO 79.1)

10. *Proposal for an Entrance Gate for a Private Residence, Washington, D.C.,* 1980. Graphite on paper, 29 x 23 in. (74 x 59 cm). Collection of the artist (GA 80.1)

11. *Proposal for a Window Grill for a Private Residence, Rochester, New York,* 1980. Graphite on paper, 23 x 14¹/₂ in. (59 x 37 cm). Collection of the artist (SCR 80.1)

12. *Preliminary Elevations of Ironwork for a Stairwell Enclosure, Hyatt Regency Grand Cypress Hotel, Orlando, Florida,* 1983. Graphite on paper, 29 x 23 in. (74 x 59 cm). Metropolitan Museum of Art, N.Y., Purchase, Grand Cypress Hotel Corporation, a subsidiary of Dutch Institutional Holding Company, Gift (1990.1021)

13. *Sketches for the Central Park Zoo Gate,* ca. 1983. Ink and graphite on tracing paper, each approx. 14 x 16³/₄ in. (36 x 43 cm). Collection of the artist (GA 83.1.2, .3, .5)

14. *Proposal for the Central Park Zoo Gate,* 1983. Graphite on paper, 30 x 40 in. (76 x 102 cm). Collection of the artist (GA 83.2)

15. *Final Proposal for the Central Park Zoo Gate,* 1985. Graphite on board, 30 x 40 in. (76 x 102 cm). Collection of the artist (GA 85.2.1)

16. *Proposal for a Window Screen for a Private Residence, California,* 1985. Graphite on paper, 23 x 29 in. (59 x 74 cm). Collection of the artist (SCR 85.1)

17. *Proposal for a Sculpture for the Wortham Center for the Performing Arts, Houston, Texas: Top Level,* 1985. Graphite on paper, 23 x 29 in. (59 x 74 cm). Collection of the artist (SCU 85.4)

18. *Proposal for a Sculpture for the Willard Office Building, Washington, D.C.,* 1985. Graphite on paper, 29 x 23 in. (74 x 59 cm). Collection of the artist (SCU 85.6.1)

9. *Sketches for Synergy, an Archway Sculpture for Museum Towers, Philadelphia, Pennsylvania,* 1986. Blue felt-tip marker on paper, each 18 x 24 in. (46 x 61 cm). Collection of the artist (AF 86.1.3, .4)

0. *Proposal for Synergy, an Archway Sculpture for Museum Towers, Philadelphia, Pennsylvania,* 1986. Graphite on paper, each 29 x 23 in. (74 x 59 cm). Collection of the artist (AF 86.2, .3)

1. *Proposal for the Main Street Bridge Railing, Rochester, New York,* 1987. Graphite on paper, 23 x 29 in. (74 x 59 cm). Collection of the artist (RLG 87.1)

2. *Proposal for the Plaza Gate, Milk Street Station, Massachusetts Bay Transportation Authority, Boston,* 1987. Graphite on paper, 19$^{1}/_{2}$ x 20$^{3}/_{4}$ in. (50 x 53 cm). Collection of the artist (GA 87.1)

3. *Proposals for Screens for the Lasdon Biomedical Research Center, Cornell University Medical College, New York, New York,* 1987. Graphite on paper, each 11 x 8$^{1}/_{2}$ in. (28 x 22 cm). Collection of the artist (SCR 87.8, 87.9.1, 87.10, 87.11.1)

4. *Study for a Wall Sconce for the Washington Hebrew Congregation, Washington, D.C.,* 1987. Graphite on oaktag, 29$^{1}/_{2}$ x 20 in. (75 x 51 cm). Collection of the artist (LT 87.3.2)

5. *Proposal for Convergence,* 1987. Graphite on paper, 23 x 29 in. (58 x 74 cm). Memorial Art Gallery of the University of Rochester, N.Y. (92.40)

26. *Proposal #1 for the Memorial Gate, Ackland Art Museum, University of North Carolina at Chapel Hill,* 1988. Graphite on paper, 23 x 29 in. (58 x 74 cm). Collection of the artist (GA 88.1.1)

27. *Proposal #2 for the Memorial Gate, Ackland Art Museum, University of North Carolina at Chapel Hill,* 1988. Graphite on paper, 23 x 29 in. (58 x 74 cm). Collection of the artist (GA 88.2.1)

28. *Studies for Confluence, Birmingham Museum of Art, Alabama,* 1988. Graphite and colored pencil on paper, 13$^{1}/_{2}$ x 10$^{1}/_{2}$ in. (34 x 27 cm). Collection of the artist (SCU 88.1.2)

29. *Studies for Confluence, Birmingham Museum of Art, Alabama,* 1988. Graphite on paper, each approx. 6 x 2$^{1}/_{4}$ in. (15 x 6 cm). Collection of the artist (SCU 88.1.3)

30. *Study for Confluence, Birmingham Museum of Art, Alabama,* 1989. Graphite and colored pencil on paper, 13$^{1}/_{2}$ x 9 in. (34 x 23 cm). Collection of the artist (SCU 88.2.2)

31. *Proposals for Confluence, Birmingham Museum of Art, Alabama,* 1988. Graphite on paper, each 12 x 9 in. (30 x 23 cm). Collection of the artist (SCU 88.1, .2, .3, .7)

32. *Proposal for Confluence, Birmingham Museum of Art, Alabama,* 1989. Graphite on paper, 29 x 23 in. (74 x 58 cm). Collection of the artist (SCU 89.2.1)

33. *Study for Aurora, Charlotte Coliseum, North Carolina,* 1989. Graphite on oaktag, 29 x 23 in. (74 x 58 cm). Collection of the artist (SCU 89.4.2)

34. *Proposal Maquette for Aurora, Charlotte Coliseum, North Carolina,* 1989. Steel, dia. 53 x 28 in. (135 x 71 cm). Paley Studios Ltd., Rochester, N.Y. (PM-1)

35. *Proposal for a Plaza Sculpture, Boston, Massachusetts,* 1989. Graphite on paper, 29 x 23 in. (74 x 58 cm). Collection of the artist (SCU 89.7.1)

36. *Proposal Maquette for a Plaza Sculpture, Boston, Massachusetts,* 1990. Copper-plated steel, 28 x 15 x 13 in. (71 x 38 x 33 cm). Paley Studios Ltd., Rochester, N.Y. (PM-3)

37. *Commission for a Sideboard for the Yale University Art Gallery,* 1989. Graphite on paper, 10 x 13$^{1}/_{2}$ in. (25 x 34 cm), 9$^{1}/_{2}$ x 14$^{1}/_{2}$ in. (24 x 37 cm). Collection of the artist (TAB 89.1.1, .2)

38. *Proposal for Plaza Sculptures and Bridge for the Rundel Library Expansion, Rochester, New York,* 1990. Graphite on paper, 32 x 45 in. (81 x 114 cm). Collection of the artist (AF 90.4)

39. *Sketches for a Railing for a Private Residence, New York,* 1990. Graphite on oaktag, 24 x 36 in. (61 x 91 cm). Collection of the artist (RLG 90.1.2)

40. *Studies for Olympia, Promenade II Building, Atlanta, Georgia,* 1990. Black felt-tip marker and colored pencil on paper, each 24 x 18 in. (61 x 46 cm). Collection of the artist (SCU 90.1.2, .2)

41. *Proposals for Olympia, Promenade II Building, Atlanta, Georgia,* 1990. Felt-tip marker on oaktag, each 18 x 16 in. (46 x 41 cm). Collection of the artist (SCU 90.1.1, 90.2.1)

42. *Proposal for a Sculpture for the Greater Rochester International Airport, New York,* 1990. Graphite on paper, 29 x 23 in. (74 x 58 cm). Collection of the artist (SCU 90.5.1)

43. *Proposal Maquette for a Sculpture for the Greater Rochester International Airport, New York,* 1991. Copper-plated steel, 51 x 34 x 15 in. (130 x 86 x 38 cm). Collection of Robert and Nancy Sands, Rochester, N.Y.

44. *Proposal #1 for the Ceremonial Gate, Arizona State University, Phoenix,* 1991. Graphite on paper, 29 x 23 in. (74 x 58 cm). Collection of the artist (GA 91.1.1)

45. *Proposal #2 for the Ceremonial Gate, Arizona State University, Phoenix,* 1991. Graphite on paper, 29 x 23 in. (74 x 58 cm). Collection of the artist (GA 91.3.1)

46. *Study for a Clock for the Grand Hall, Orlando Airport, Florida,* 1992. Graphite on oaktag, 24 x $22^{3}/4$ in. (61 x 58 cm). Collection of the artist (AO 92.1.1)

47. *Study for a Sculpture for the Reading Terminal Convention Center, Philadelphia, Pennsylvania,* 1992. Graphite and colored pencil on paper, $27^{1}/2$ x 76 in. (70 x 193 cm). Collection of the artist (SCU 92.3.2)

48. *Proposal Maquette for a Sculpture for the Reading Terminal Convention Center, Philadelphia, Pennsylvania,* 1992. Polychromed steel, $23^{1}/2$ x $66^{1}/2$ x $37^{1}/2$ in. (60 x 169 x 95 cm). Paley Studios Ltd., Rochester, N.Y. (PM-7)

49. *Proposal for Sculpture Screens for the Federal Courthouse, Camden, New Jersey,* 1992. Graphite on vellum, 22 x $46^{1}/4$ in. (56 x 117 cm). Collection of the artist (SCU 92.5.1)

50. *Sketches for the Tabernacle Screen, Temple Israel, Dayton, Ohio,* 1993. Graphite on paper, $22^{1}/2$ x $28^{1}/2$ in. (57 x 72 cm). Collection of the artist (SCR 93.1.3)

51. *Proposal for the Tabernacle Screen, Temple Israel, Dayton, Ohio,* 1993. Graphite on paper, $22^{1}/2$ x $28^{1}/2$ in. (57 x 72 cm). Collection of the artist (SCR 93.1.1)

52. *Proposal for a Sculpture for Asheville, North Carolina, and for a Sculpture for an Athletic Complex, Japan,* 1993. Graphite on paper, each 14 x 11 in. (36 x 28 cm). Collection of the artist (SCU 93.1, .2)

53. *Proposal Maquette for a Sculpture for an Athletic Complex, Japan,* 1993. Painted steel, dia. $10^{1}/2$ x $5^{1}/3$ in. (27 x 14 cm). Paley Studios Ltd., Rochester, N.Y. (PM-8)

54. *Study for a Large-Scale Vessel,* 1993. Graphite and red pen on paper, $63^{1}/2$ x $39^{1}/2$ in. (161 x 100 cm). Collection of the artist (SDA 93.3)

Selected Bibliography

BOOKS

Bach, Penny Balkin.
Public Art in Philadelphia.
Philadelphia: Temple University Press, 1992.

Barquist, David L.
American Tables and Looking Glasses.
New Haven: Yale University Art Gallery, 1992.

Conway, Patricia.
Art for Everyday: The New Craft Movement.
New York: Clarkson Potter, 1990.

Diamondstein, Barbaralee.
Handmade in America.
New York: Harry N. Abrams, 1983.

Jensen, Robert, and Patricia Conway.
Ornamentalism.
New York: Clarkson Potter, 1982.

Hoffmann, Gretl.
Kunst aus dem Feuer.
Stuttgart: Julius Hoffmann, 1987.

Miller, R. Craig.
*Modern Design in the Metropolitan Museum of Art:
1890–1990.*
New York: Harry N. Abrams, 1990.

Minamizawa, Hiroshi.
*The World of Decorative and Architectural
Wrought Iron.* Kyoto: Yoshiyo Kobo, 1990.

Park, Edward S.
Treasures of the Smithsonian.
Washington, D.C.: Smithsonian Institution, 1983.

Southworth, Susan and Michael.
*Ornamental Ironwork: An Illustrated Guide to Its Design,
History and Use in American Architecture.*
Boston: David Godin, 1978.

EXHIBITION CATALOGUES

Albert Paley: Organic Logic.
New York: Peter Joseph Gallery, 1994.

Albert Paley: Sculptural Adornment.
Washington, D.C.: Renwick Gallery of the
National Museum of American Art,
Smithsonian Institution, 1991.

Albert Paley: Sculptures.
Philadelphia: Rosenwald-Wolf Gallery,
Philadelphia College of Art and Design
at the University of the Arts, 1992.

Albert Paley: The Art of Metal.
Springfield, Mass.: Museum of Fine Arts, 1985.

Baroque Modernism: New Work by Albert Paley.
New York: Peter Joseph Gallery, 1992.

The Metalwork of Albert Paley.
Sheboygan, Wisc.: John Michael Kohler
Arts Center, 1980.

Paley/Castle.
Ithaca, N.Y.: Herbert F. Johnson Museum of Art,
Cornell University, 1974.

Paley/Castle/Wildenhain.
Rochester: Memorial Art Gallery,
University of Rochester, 1979.

Towards a New Iron Age.
London: Victoria and Albert Museum, 1982.